Sleepwalk Collective's

Kardashian Trilogy

Salamander Street

PLAYS

First published in 2020 by Salamander Street Ltd.
(info@salamanderstreet.com)

Kardashian Trilogy © Sleepwalk Collective S.C., 2020

Kim Kardashian photos by Vinicius Alonso

Khloé Kardashian photos by Arden School of Theatre (UCEN Manchester) and Sleepwalk Collective

Kourtney Kardashian photos by Sleepwalk Collective

ISBN: 9781913630089

Printed and bound in Great Britain

10 9 8 7 6 5 4 3 2 1

CONTENTS

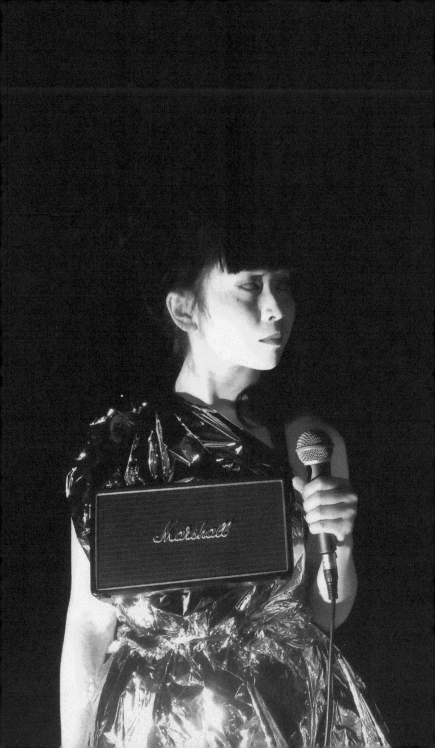

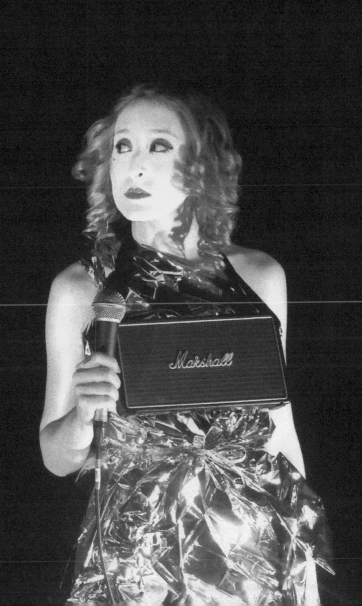

NOTES ON THE TEXTS

One perfectly reasonable question is why exactly have we made a trilogy of shows named after the Kardashian sisters, and the answer to that question is both profound-ish and also not very, in its various constituent parts. A first and short-ish answer would run like this: the three texts in this book, and the shows that hold them, were the product of a series of unusual commissions and work done at speed – an invitation in 2016 to make a show with the Balé da Cidade de Palmas, a young ballet company in Tocantins, Brazil, was followed by another invitation in 2017 to make a show with Theatre and Performance students at The Arden in Manchester, which was then followed in turn by an invitation in 2018 to propose a show for the Festival de Clásicos en Alcalá, Spain; parallel to that, a title chosen almost at random suggested the titles of the shows that would follow it, and similarly the form of the first show – a ballet – suggested that the following shows would be a stage play and an opera. And so here we all are now. Sometimes that's just how these things go.

A second version of an answer: the fact is of course that the three sisters are a pretty neat synecdoche for a whole frenzy of 21st century obsessions and anxieties, for the blurring together of the real and the unreal and for our Extremely Online lives lived as much as anything to be looked at, watched, by others and by ourselves. Kim Kardashian especially seems like the first celebrity who's truly native to this dazzling new age: where with her predecessors there was always a degree of separation between their public and private personae – the sense (knowledge?) that what we were seeing was to some extent or other *performed* – with KK it's completely possible to believe that her public persona is *who she actually is.* There may be, in a sense, no other face behind the mask. And there's a near-terrifying kind of honesty at work here (I mean, *just imagine*), a starkly naked truthfulness (we may be projecting here but still), a realness that is *realer than real* whatever, if anything, that's supposed to mean.

A third answer: in these shows we have used the titles to make certain ideas and connections and possibilities present – visible, felt – without them having to be named. That there are possible relationships between modern celebrity and the opulence and excesses of classical artforms is perhaps obvious enough that it doesn't need to be directly pointed at; likewise the potential connections between "reality" TV and staged "naturalism"; and if this all feels almost claustrophobically meta and self-conscious it's kind of supposed to… The intention – as it often is in our work – is to allow unusual things to sit together in unusual arrangements, allowing the

frictions and resonances that emerge between them to do the work. This is neither particularly radical nor particularly avant garde – we all perform essentially the same action whenever we skim through social media feeds, finding banal commentary next to emotional outpouring next to news-story-horror next to garish advertisements. Sometimes something emerges, a connection, a kind of poetry, all of it making a kind of occult, cumulative sense, forming a bizarre communicative texture that now feels so familiar it's almost homely. In constructing work within this particular language we accept that the connections will sometimes emerge and sometimes won't, and that this experience is at least partly subjective and personal; plus also, time-bound – at the time of writing the three sisters are still very much alive, and the things that they will do throughout the rest of their lives might come to shape the meanings – or at least, the readings – of these texts in unexpected ways. We'll have to wait and see.

So whatever it is that you see in these relationships – whatever you find in these texts – is fundamentally correct, but we can still talk about some of what *we* saw, sometimes, in all of this: a surface of stilted formality and domestic banality with this overwhelming rush of emotion – of music – running irrepressibly beneath it; a scattering of family albums (we're in there somewhere, too), all overlain until they become indistinguishable from each other; real live bodies dancing with a body willingly transformed – meticulously, ruthlessly – into pure image, depthless, flattened and manipulated to the point where it becomes almost hieroglyphic, like a new character in an alphabet that we haven't really learnt to read yet.

A final version of an answer, simpler but equally true: We always start with the title, and the title should at first be meaningless; Kim Kardashian is an objectively beautiful name, both phonetically and when written on the page.

And then on top of and beneath and folded into all of that, these three shows were created in (or *in relation to*) three specific art forms – a ballet; a stage play; an opera – and all that these specific forms carry and imply. And the three shows should be read essentially as *parallel texts*, existing primarily in relation to other (existing) works – a dance piece (which could almost be *any* dance piece); Chekhov's *Three Sisters* (because *of course* three sisters); and Mozart's *The Marriage of Figaro*. It's important therefore to acknowledge what's missing from these pages, and to note the deliberate gaps and spaces that the texts leave both for those pieces and for the tornados of associations that those pieces drag behind them. Even onstage, there is

a kind of play of absences – we are not a ballet company, or a theatre company in any conventional sense, and we're certainly not an opera company, so we have kind of gestured, playfully, towards those forms, allowing the gaps and shortcoming and cheerful moments of failure and lack to resonate somehow. And so in the shows the dancers are often not dancing; the play is not, in any real sense, performed; the opera has no singing in it. Instead we have worked with the structures and tropes, the beauty and the decadence, the archaic formulism, all the time trying to create spaces for you, the audience, to imagine inside of. And if much of it reads as inherently critical – and kind of sardonic – know also that it all comes, fundamentally, from a place of love.

What we're left with in the end is this: a three-part dream or nightmare about beauty and history and excess and money and art and boredom and bliss, in which we see a woman dragging a swarm of pink balloons across a stage littered with banknotes, a man dressed as a bear getting shot with a nerf gun and lying dead in a pile of fake snow, two women dressed in emergency blankets eating gold leaf in a cloud of haze… Three shows made quickly and almost by mistake and then performed only a handful of times. This book is what's survived of them. We hope that you enjoy it.

Sammy (2020)

ADDITIONAL NOTE:

We have chosen to present the three texts in this book without stage directions, and without giving detailed indications of how the texts are divided between voices – that we performed them one way does not mean that they cannot be performed any other way, and we prefer to leave that open to the imagination. We have though included, in an appendix at the end, some brief descriptions of some of the stage images, especially for moments where this might help to clarify the meaning of the text. This information should be regarded as optional.

KIM KARDASHIAN

A Ballet

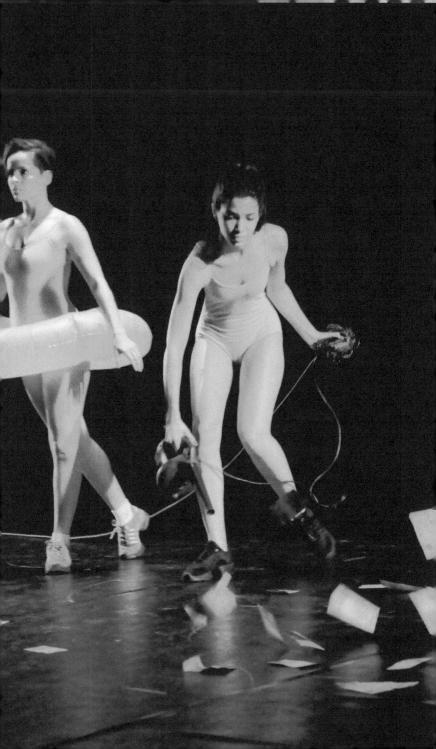

Written for Sleepwalk Collective
And the Balé da Cidade de Palmas
By Sammy Metcalfe

With iara Solano Arana

Between 2016
And 2017

Kim Kardashian was made with Alex Fernandes,
Amanda Adelides, Átila Gonçalves, Carine Silva,
Christopher Brett Bailey, Crislla Segato, Daniela Perez,
Elton Fialho, Renata Oliveira, and Tarleison Souza

Kim Kardashian *was written as a text to accompany a ballet performed by the Balé da Cidade de Palmas, although we always liked the idea that it could potentially accompany any dance piece. The text was written to be projected, and in performance it appeared on the back wall as a series of text messages, as if you (the audience) have left your phone on and these are the messages that you're receiving, one at a time, as you watch the show.*

hi [1]

hi?

did i wake you?

i cant sleep

whenever i close my eyes i see stars exploding [2]

over and over like a gif inside my head

and maybe its my thoughts exploding

all my memories burned white and gone forever

a million pictures all of my own face blown like confetti

nevermind

my sisters are riding a black horse naked into the sun

lol

thats a lie

my sisters are riding a white dragon naked into the sun

youve got to see it to believe it

nobody on television will ever die [3]

because we are all xochiquetzals baby children

and together we will be reborn as butterflies

im a mess tonight

you should see me

mirror mirror on the wall

i could stare into the mirror forever probably

until my eyes grow so big they swallow my whole face

a face is like an advert for the person who has it [4]

for whatever theyre thinking

my face is blank as paper

i cant tell if im smiling underneath this makeup

oh hey do you mind me telling you all of this?

i have nobody left to talk to

this phone is like a dead bird in my hand

where was i?

my god the things i have seen and done

i have watched the sunrise over the desert

i have watched the sunset over the sea

i have felt lovers moving inside me

i have seen my children pulled bloody and screaming from inside my own body

i have bathed in a million eyes

a million eyes white like milk

snake biting at my breast

i have drowned all my other selves in the river

this is whats left

laid out on this bed like a jellyfish washed up on a beach [5]

skin glowing transparent in the phonelight

eyes lit like dollar signs

defenceless as a newborn

like im a giant version of my little girl

seems impossible that another person has come out of this body

but she did

i wonder whats going to come out next

tonight she asked me for a story and i told her:

"once upon a time there was a beautiful princess...

...and she lived in an enormous castle surrounded by wolves...

...and at night she could hear the wolves calling to her...

...and when she slept she dreamt of sharp teeth around her throat... [6]

...and she was happy"

i dont know why i said that

i dont know what i was thinking

of course nature is a cruel lover

some insects eat their lovers alive

some animals eat their young

newborn spiders eat their mothers

unborn sharks eat their sisters while still in the womb [7]

what has happened to us?

whenever did we get so old?

when i was a little girl every heartbeat was white light and heat

and my blood danced in my veins

gentle

7

quick

now sometimes i can barely feel myself

in my wildest dreams we are two transparent things way down at the bottom of the ocean

moving slowly together in an infinite blackness

wrapped around each other in an endless embrace

i wish you could see what i can see now

the fan on the ceiling drifting like dead leaves in a river

the tv showing a perfume advert

everything too beautiful to describe

wait

i think im gonna pee myself

wait wait wait

...

no its ok

as long as i dont move its ok

hey

are you at that dance thing [8]

???

and have you left your phone on

i know that youre getting these messages

is everybody like

SWITCH YOUR PHONE OFF

ha ha ha

i can almost picture you

sat in the audience

distant and small like through the wrong end of a television

wrong end of a telescope i mean of course

(autocorrect ha ha ha)

assuming of course that youre there

assuming that theres anybody actually out there

reading this

and that im not just talking to myself

hi?

hi

impossible to know i guess

not gonna stop writing tho

too late now [9]

lets play a game

lets imagine that i am one of the dancers in front of you

can you see me?

who do your eyes always follow?

who are you watching closest?

thats me

right there

and are you charmed?

are you seduced?

i wish i could see what you see now

see myself from the outside

do i seem happy? [10]

do i seem sad?

do i seem lonely up there on the stage

my love

i close my eyes and i can almost feel her

feel her on the inside

feel myself inside a body that is not my own [11]

a body moving out of my control

her mind is perfectly blank

but i can feel her blood pumping through her veins

her organs moving underneath her skin

and hear faint messages sent from distant parts

a foot

a fingertip

lungs

heart

whispering hungers

wishes

desires

the audience watch like hungry ghosts

i can feel your eyes on me

like a caress

and then i open my own eyes and here i am still [12]

dressed again in myself

already made up

already posed

the walls and furniture all staring back at me

tv cameras always KEEPING UP

i should burn this fucking house down

look at them all

lined up on the stage like toys

like pieces in a board game too complicated to follow [13]

i have no idea whats going on inside their heads

their dreams and their nightmares

perhaps shes thinking about a sky full of stars

perhaps shes thinking about her sisters eyes

perhaps shes just thinking about her next step [14]

we are a mystery to one another

7 billion bodies moving together across the earth now and forever

like an immense shoal of fish

a lake of swans

a flock of birds [15]

moving together with an impossible grace

moving towards nothing in particular

spinning across a dawn sky lit up like a house on fire

it doesnt mean anything

that doesnt matter [16]

and does my blood still dance in my veins

or does it fall over itself

like people escaping a crashed plane

a mountain of bodies all piled up on top of each other

a million tiny people filling me up inside

my heart my lungs my stomach my head everything

everybody i have been and will ever be

a whole city of sleeping girls

all with my face and my body

my love

im falling into a dream [17]

always forever the same dream

in the dream i am in my teenage bedroom

floating ghostlike facedown

six inches above my own sleeping face

i look so peaceful with my eyes closed

she is both myself and not myself

i remember her sorrow that was my sorrow

her loneliness that was my loneliness

i want so very much for her

i run my hands over her face that is my own mirror

i am gentle

i know just where my hands should go

i give myself everything i remember wanting

it is the longest night of my life

its late [18]

my battery is dying

the dancers are leaving the stage

blow them all your kisses

for one last moment i point myself at them and at you

like a flower pointed at the sun

i am the aerial

i am the signal and i am the noise

one day ill look in the mirror and see nothing at all

empty air crowned with light

queen of nothing [19]

god of nothing

bride of nothing

dream of nothing

ghost of nothing

gone

ADDITIONAL TEXT

*The following additional text was recorded in six different languages – by Daniela Perez
(in Portuguese), Gloria March Chulvi (in Valenciano), Haruka Abe (in Japanese), iara
Solano Arana (in Spanish), Jess Latowicki (in English), and Malla Sofia Pessi (in
Finnish) – and then chopped up and mixed in with the music, used as sound rather than text.*

Hello
Hello baby
I love that we have these memories
I can almost taste them
On my lips
On my tongue
And feel them
On the tips of my fingers
On my palms
On the back of my neck
My throat
My stomach
My thighs
My eyelids
My cheeks
All of everything pressed up against the outside of my skin
All of myself pressed up against the inside
I open my mouth and my heart curls out like smoke
Why won't you pick up the phone?
Where are you now anyway?
What are you thinking?
What's the worst thing you've ever thought?
Sometimes I wish you were crueler
 (Laugh)
I could talk into your voicemail forever
Forever and ever and ever
I can't help myself
I've got all my best thoughts on speed-dial
All my best feelings
I can't feel my face anymore
I can't feel myself

Just the phone's receiver
Warm and plastic against my ear
And the blood in my head
Heavy like a blanket
I'm sleepy
I'm sleeping
I'm gone
Sorry, I'll be back
Don't be long
One more?
Later

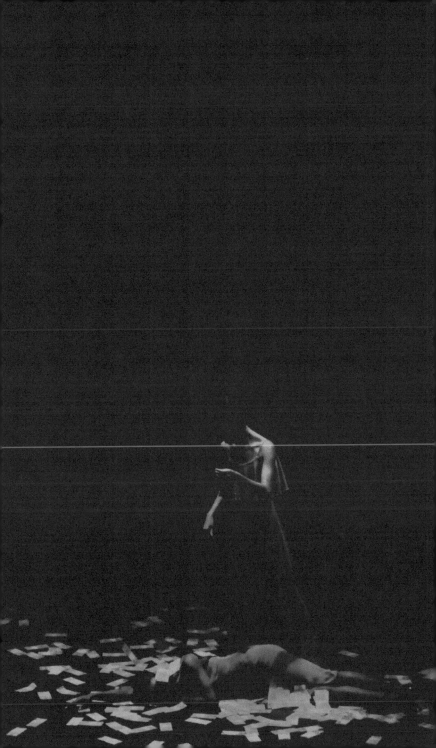

KHLOÉ KARDASHIAN

A Play

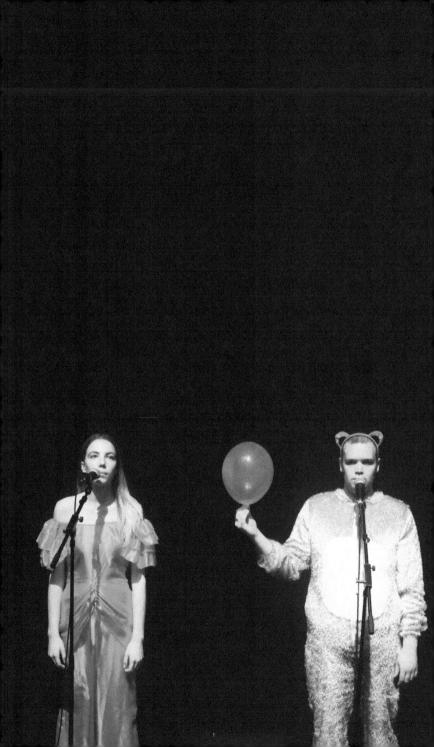

Written for Sleepwalk Collective
By Sammy Metcalfe
And iara Solano Arana

With Paul Burke
And Tristan Chadwick
And Lily Rae Hewitt Jasilek
And Sam Lowe
And Frank Macdonald
And Kate Smith

In 2017

Khloé Kardashian was made with help from
Alex Fernandes, Angela Wayland, Carol Wilson,
Cassius Murray, Christopher Brett Bailey,
Debbie Uttley, Jack Dale, Joseph Reynolds,
and Wayne Steven Jackson

Khloé Kardashian *was written as a text to accompany Chekhov's* Three
Sisters, *sections of which (complete with stage directions and the announcement
of new scenes) were projected continuously, running in "real time" throughout
the show. Here we've only hinted at the presence of the original Chekhov text,
but if you have your own copy of the play you can try reading it parallel to this.*

² You have come to the theatre again
You have travelled from wherever you have travelled from
You have arrived
Early or late or just in time
Perhaps you have waited around
Perhaps not
And then at last you have stepped into the darkened auditorium
And you have taken your seat
And you have watched the lights go slowly down
And now you are here

You are breathing

You are thinking

You are looking at what's in front of you
Sometimes blinking
Sometimes looking around
You have noticed the stage
You have noticed the light
You have noticed the darkness around the light
You have noticed my voice
You have noticed my personality perhaps
You have noticed the expression on my face
You have noticed that we are not so very different
You and I
That I am a person just like you
More or less
More
Or less
You might feel that I am relatable
That you can relate to me

One human being to another
Here I am
For you
And if you have detected a certain amount of nervousness
Don't worry
Because this is my thing
This is what I do
[3] You have come to the theatre again
But what do you think you're doing here
What exactly are you looking for
Maybe you have come here to escape from the world outside
From your wife who is sleeping with the milkman
You husband who is sleeping with your best friend
Or maybe you have come to escape yourself
Or to find yourself
Maybe you came here because you are the kind of person who
 likes to watch
Maybe you have come here tonight to laugh and cry
To share in other people's joys
Or to wallow in other people's misery
To wade out into other people's misery
So you can see it up close
Other people's pain and other people's sorrow and other
 people's grief
Maybe you came here tonight to be shocked
Or charmed
Or held
Or loved
Or taken somewhere
Or seduced
Or bored

Maybe you came here tonight to prove something
But we can talk about that later
Maybe you have come here to feel a part of something
You're not part of something
You're not part of this
But we can talk about that later

But whatever your reasons
You have come to the theatre again
This theatre
You have noticed the objects on the table
You have noticed the gun
That must be fired in the third act
And what if it's really loaded
And what if something goes wrong
And what if this never gets better
What if this
This right now
Is all there is
Is all that there's going to be
The stage in front of you is dressed up to look like a drawing
 room
Right now there are a number of men and women arranged
 around it
They are talking about happiness

[5] Three sisters live together in an enormous house
A house in the middle of nowhere
And every day
They work to conceal a pristine kind of sadness
A sadness that is like a kind of precious metal
A diamond
A gem
A sadness that is like a kind of money
To be kept locked up safe
In the strongest and most secret vault in all the world
And if they are not always completely sure what's real
 and what isn't
At least they have each other
And they are inseparable
And the family resemblance is impossible to miss
The same eyes
The same lips
The same hands
Their voices identical or close enough
Sometimes it is difficult to tell where one of them ends
And the other begins
And if their lives do not always feel entirely real to them
As if they are characters in a movie
Characters in a play
They know at least that their lives are memorable
That they will be remembered
Forever
Or close enough

[6] What you're seeing up there is a kind of slice of life,
 we might say
Real people in real situations
A kind of reality show if you will
A slice of life cut really, really thin
Which makes it easier to digest
Instantly gratifying and smooth all the way down
And though they might sometimes pretend that they don't know
 we're watching
We know
That they know
That we are
And they are undeniably safe behind their forth wall
Safe from us and from you
Unlike here
Where you could break the forth wall just by getting up
 and walking towards us

You won't

But you could

That applause means that we are already at the end of the
 first act [7]
Doesn't time fly
Here comes the second act now
And here comes Sam with the science bit

<div style="border: 1px solid black; padding: 1em;">

Act Two. Evening.
Natalya enters with a candle.

</div>

[8] The theory of parallel universes proposes
That there is a near-infinite number of other realities
All happening simultaneous to this one
All running alongside us
Almost near enough to touch
And in all of them except for this one
You are somewhere else right now
In most of them you are currently watching *Three Sisters*
 by Anton Chekhov
So welcome to the naturalistic theatre why not
Welcome to the classical theatre
Where LARPing
Meets Cosplay
Where the acting is serious
And weighty
Where the actors really work for you
And sweat runs down their brows
Where the actors project their voices
And believe in what they're saying
Believe it with all their hearts
And so you can just sit back and relax
And let the acting happen to you

<div style="border: 1px solid black; padding: 20px;">

**Vershinin and Tuzenbakh
are talking about time.**

</div>

You are now experiencing when acting is an art

You are now experiencing inner motive forces

You are now experiencing emotion memory

You are now experiencing the threshold of the subconscious

You are now experiencing action

You are now experiencing communion

You are now experiencing faith and a sense of truth

You are now experiencing relaxation of muscles

You are now experiencing "thinking"

You are now experiencing "feeling"

[9] Let's not overdo this
Let's not have any silliness
Let's not have any messing around
We can all just…
…act natural
As natural as can be
Let's not have any drama
No mechanical gestures
No exaggerations
Let's all just be normal
What could be more obvious
Or more true
And what are we if not suckers for the truth
The real truth
The biggest truth
The truest truth
Like the bluest blue
The blackest black
The darkest dark
The quietest quiet
The realest real
A realness that is realer than real
A realness that is pure and absolute
A realness that is almost crystalline
Sharp as a knife

Ladies and gentlemen
We now present an authentically ordinary moment
Taken directly from real life

[10]

Act Three. Night.
Outside there is a fire.

[11] I've been watching you
Watching us
Watching them up there
And, you know
That's good
Bit of theatre
Bit of Chekhov
Bit of culture
You know
Self-improvement

Edifying

Good

Give yourselves a pat on the back

What else?

Everyone wants happiness
No one wants pain
But you can't have a rainbow without a little rain

I don't know

Don't cry because it's over, smile because it happened
Your wings already exist, all you have to do is fly
A journey of a million miles begins with a single step
If plan A doesn't work, the alphabet has 25 more letters
I don't know

> **Chebutykin, drunk,**
> **is talking about failure.**

If you're going through hell, keep going
Why wait for the storm to pass when you can learn to dance
　　　　in the rain

Live

Laugh

Love

Put your positive pants on
And, you know…
…life goes on

That's about all I've got
I'll be back again later
To read the end of the show

[12] Here we all are then
Somewhere in the third act now
There has been a secret affair
There has been a declaration of love
There has been a house on fire
Seasons have changed and people have grown older
It is not always easy to follow
Your eyes drift back and forth across the stage
Your thoughts wonder

Look at us
We're harmless
We wouldn't hurt a fly
You have nothing to fear but each other
And you might want to ask yourself now
"What's the worst that could happen"
And buddy
I've got bad news
Because how much do you really know
About the people you are sitting amongst

**Chebutykin, drunk,
is talking about violence.**

Is there a doctor in the house?
Is there a lover in the house?
Is there a liar in the house?
Is there anybody lonely in the house?
Anybody with a heart condition?
Anybody sick?
Is there anybody contagious in the house?
As there you all sit, breathing each other in
Is there a birthday boy in the house?
Is there a family man in the house?
Is there a midwife in the house?
Is there a housewife in the house?
Is there an ex-con in the house?
Is there a cycling enthusiast in the house?
Is there an electrician in the house?
Are there any Siamese twins in the house?
Is there anybody sleeping in the house?
Is there anybody in the house?

[13] You get what you pay for
And what you have paid for in this case
Is a specifically Russian flavour of despair
Plus of course Russian drama
Russian dignity
Russian heartbreak
Russian terror
Russian grief
Russian jealousy
Russian tedium
Russian madness
Russian solitude
Russian fatalism
Russian fate
Russian blood
Russian blood spilt over Russian snow
Out in a Russian wilderness
Under a Russian moon
Russian blood spilt from Russian bodies
Russian blood spilt from the Russian soul
And in the theatre
We can place a glass over all of that
And slide a piece of paper underneath it
And carry it all gingerly outside
And release it safely back into the wild

Ladies and gentlemen
We now present a climax
And an anticlimax

[14]

[15] The sun falls, the snow falls, the night falls, the light falls
You go to the theatre again
And for a short time you are absorbed inside of something
 bigger than yourself
And sometimes
If you listen very closely
You can hear what it's trying to tell you
Or what it only *seems* like it's trying to tell you
In an imagined voice
Like the voice you sometimes think you hear
In the static between radio stations

And that voice can say whatever you want it to

Because it's not really there

The time is running down now
The same time for all of us
We'd like to take a moment just to feel it passing
Give us this, if you can
We won't ask anything else of you tonight
We're almost at the end

**The three sisters
are talking about hope.**

[16] Three sisters live together in an enormous house
A house in the middle of nowhere
And every day
They are bathed in a hundred eyes
A thousand eyes
A million eyes
A million eyes white like milk
Eyes watching from the darkness of the auditorium
Eyes watching from the darkness of their own homes
And if their lives do not always feel entirely real to them
As if they are characters in a movie
Characters in a play
They know at least that their lives are memorable
That they will be remembered
Forever
Or close enough

Sisters [17]
You will never have this day again
Never ever ever ever ever again
You might as well live it
So drown your sorrows in the river
Burn your sorrows behind the old red barn
Carry your sadness
Corpselike
Bodylike
Alone
Carry your sadness out into the forest with a shovel
And bury it amongst the trees

[18]

KOURTNEY KARDASHIAN

An Opera

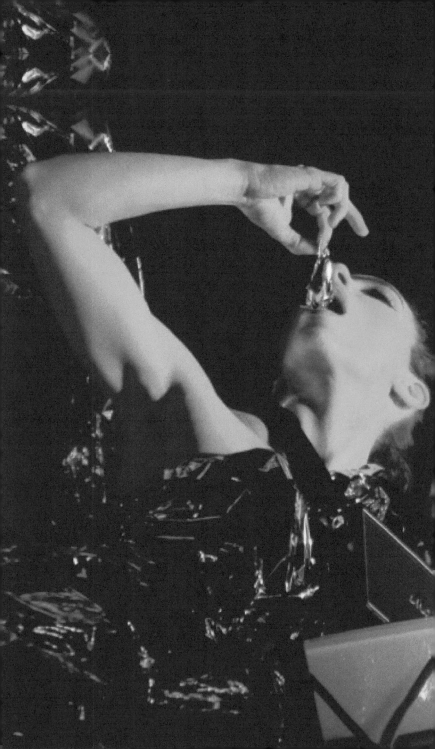

Written for Sleepwalk Collective
By Sammy Metcalfe

With iara Solano Arana
And Rebeca Matellán
And Nhung Dang

Between 2018
And 2019

Kourtney Kardashian was made with
Lucy Metcalfe and Stephen Metcalfe

With help from Sarah-Jane Watkinson

Kourtney Kardashian *was written as a text to accompany Mozart's opera*
The Marriage of Figaro, *extracts from which – sung by Sammy's parents,*
pre-recorded – were played through amplifiers worn (like second voices) around
the performers necks. The text itself was written for two voices (iara and Rebeca
in the Spanish-language version; iara and Nhung in the English-language
version), with a third voice (Sammy) appearing in projections. The content of
that projected text – which appears here in italics – is essentially true. The titles
of the different sections, which are explained in a glossary following the text,
were also projected.

[2] *Good evening.*
It's me, over here.
The conductor.
There is no orchestra.
There are no musicians.
But still I raise my hand like this –
and the music starts to play.

OVERTURE

[3] Tonight, somewhere, somebody is singing
Not in here
There will be no singing in here tonight
But somewhere
In bars
In houses
In the open air
Dead drunk in karaoke booths
Eyes closed in the shower
Grouped around a cake with candles on it
In bedrooms and forests and shopping malls
In car parks and concert halls
Out at sea
Everybody holding on to one another
Everybody alone
Alone behind the wheel
Alone in the passenger seat
Barely conscious of their own lips moving
Our parents perhaps
Our brothers and sisters
We are all of us brothers and sisters
It is tempting sometimes to think of the opera as unnatural
As unrealistic
The way in which everybody bursts into song
But people do sing
Sometimes they simply cannot help themselves
Tonight, somewhere, somebody is singing
We cannot hear them from here
Any of them
But we can imagine that we could
If this roof could lift off
If these walls could fall down

If we could hear them
A ghost-choir of voices stretched all across the earth
Filling every note on the scale
If we could hear them
White noise and pool of voices
The despair of that
The love and longing of that
Unspeakable
And hopelessly human
There are no longer any gods
No angels
No devils
There's just us now
There are no spirits
No white-sheeted ghosts
Our dead have left us and they're not coming back
There is no magic
No witchcraft
Just cold hard facts
And how we choose to live with them

That's all there is to say
The stage is ready now
Welcome

⁴ This is my mother's voice.
She is singing one of Rosina's arias from Mozart's
The Marriage Of Figaro.
It is 1992.

PRELUDE

We picture this:
The curtain has come up
And now you're watching rich people in a house
And on the stage in front of you
Their tiny dramas will play out
At maximum volume
And at maximum expense
There will be endless costume changes
Men dressed as women
Women dressed as fantasy versions of themselves
They will pretend that they don't know we are watching
But we'll know
That they'll know
That we are
And we might find them a little hard to take seriously
With their painted faces and melodramatic gestures
But if we're very lucky
They'll sing loud enough to break glass
With such feeling
With such sincerity
That you will cry yourself dry
That much at least we can hope for
Can you picture that for me?
Are you listening closely?
Are you all sitting comfortably?
At the opera
Everything is layered up like Figaro's wedding cake
Under the words
There is the singing
And under the singing
There is the music
And under the music

There is this
And us
And you
Tonight we see here not the opera
But instead something like the wrapping paper peeled off of that
The sparkle and charm of that
Wafer thin

And right now
Up on that surface
Figaro has just been measuring a room

[5] *This is my father.*

Unlike when the birds sing
Our singing performs no function
Whenever we finish singing
Nothing new has been achieved
Nothing in the world has changed
Our singing is a quirk of evolution
A leftover
An echo
As pretty as it is useless
But nonetheless full
Inside of our own voices
We hear the voices of our parents
Inescapable
As if suspended in formaldehyde
Listen now
To my mother and her mother and her mother
Carved into my every vowel and consonant
My 24 years of grief and joy
Although of course I might be just performing that
And this accent might be fake
Like my voice is wearing fancy dress
And maybe I'm thinking too much
About these words
And where I put my lips
My tongue
You'll never know
Our voices are full and waiting
Waiting to be transformed by the music of an 18th century
 genius
Into truth and meaning
Let's give ourselves in to that
To an art form that is dying
Made for people who are dying
By people who are dead
To perform an opera is in part to perform a kind of séance
The notes on the score arranged like letters on a Ouija board
And the dead bodies pile up in mounds

DUET

But we're getting ahead of ourselves
Before that
There will have to be young lovers [6]

 Aging fools

Susana with her bridal veil

 The gardener with his crushed flowers

Cherubino with his love letters

 And the Count

Plunged now into a baroque kind of despair

 Always horny

Always depressed

 Practically kissing his biceps between arias

And the Countess with her sorrows

 Carrying a sadness that is like a kind of
 precious metal

A diamond

 A gem

A sadness that is like a kind of money

 Backstroking through that like a cartoon duck

Don't worry if you're not following all that by the way
Nothing ever really happens in the opera
And what does happen is often too complicated to follow anyway
But we can try anyway to picture them all
Singing their way through a plot we cannot see from here
Carried by the music like it's a kind of tornado
A tidal wave of emotions
With everything arranged around them just like in real life
Only it feels a little off somehow
The leaves on the trees just a little too static
The moon just a little too bright

In 1992 my parents are singing in The Marriage Of Figaro.
I am eight years old.
I am the smallest person in the room.
Through a child's eyes and ears,
the images and music come like a dream.
Expressing feelings that I cannot yet imagine feeling.
Thoughts that I cannot begin to articulate.
The grown-up world floats in front of my eyes like a lit veil. [7]
Impossible to grasp or to see through.
But although I don't understand
what my parents are singing about,
I know instinctively that it is something terribly old,
and terribly clever.

Tonight I am trying to recreate that the best I can.
So I can see it again.
So I can see them again,
as they were when we were all younger.

CLAQUE

Our memories are labyrinths
Full of people walking around
The living

And the dead [8]
All of them gesturing towards us from a past we will never
 see again
Trying to tell us something important we have perhaps forgotten
Bearing gifts and secrets and regrets
Lost friends
Distant relatives
Characters from half-remembered TV shows
Mozart, even
And any other ghosts that have gotten caught up in
 the machinery
As we rush together into the future
And if it's sometimes easy to get lost in memory
It is undoubtably more comfortable in there
And who could blames us
For choosing nostalgia
For choosing comfort and control
Over the real world in all its messiness and sharp edges
It isn't a lie exactly
It's just simpler
To choose a world where everything does whatever we want it
 to do
That runs so smoothly and automatically
That it doesn't necessarily need us to live in it

 We have set up these speakers [9]
With their canned laughter and applause
So that we won't need you anymore
Your work as an audience has been outsourced

To machines
As with all things eventually
The machines have taken your place
And they are perfect
They will never be disappointed
They will never protest
Their applause will always be unanimous
And unlike you
They will laugh in all the right moments
They will know when to feel moved
And they will throw flowers
Once we've built them their arms
And so without you
The audience
To ruin things
We can get on with the real business of the opera
Which is of course destroying our rival's careers
I'm going to push her down the stairs when the show ends

 I've put broken glass in her canapés

I've cut the brake lines in her car

 We can carry on with the business of swapping prop knives
 for real knives
We can carry on with the backstabbing both literal
 and metaphorical
And in the meantime you can just sit back
And allow yourselves to decay
Sink into your blood and acid and bile
Let's let our bodies rot together
Our bodies
On top of your bodies
Let's let our bodies turn to coal
And in a billion years time
We'll be crushed into a diamond

Let's call ourselves an investment

Let's call ourselves money in the bank

But memories refuse to behave themselves. [10]
The scenes come in the wrong order and at the wrong time.
Friends and lovers swap places like in a game
of musical chairs.
They come with new outfits and new faces and in the most unexpected places.
And their words come out all jumbled.

Oh god I'm losing the plot.

CAVATINA

[11] It's nice to see you
The elite
One would sort of have to assume
In a place like this
Unless there's any…
…riffraff…
…who have crept in the back
But in any case yes
The elite
The intelligentsia
The crème de la crème
You look exactly how I imagined you would
Placid
Unfazed
A little skeptical perhaps
A little removed
We have done everything in our power
To meet your needs
This gold is clearly fake
It's an emergency blanket
It's just gold-*coloured*
And almost valueless

But *this* [12]

This here

This is the real thing
24 carat and almost pure
Dug out of the ground somewhere in Africa
Treated
Squashed flat
Flown across the world

And sold over the internet
To us
It's one of the most precious things we have ever bought
So as you can see
We have spared no expense

CABALETTA

Look at us
Dripping shimmer like we napalmed a goldmine
Like we napalmed a bank vault
And I hope that you're dressed up properly out there
Dressed for the occasion
Dressed for the kill
Maybach waiting outside
Lamborghini waiting outside
Rari
Bugatti
Horse-drawn fucking carriage
Motors running
Ride or die
I hope that you're dressed to the nines out there
Champagne at the interval and polite applause
Tonight we can feel safe behind a vast wall of luxury
Acres of velvet
30.000 kilowatts of electricity
Marble statues of crying angels
Fountains pissing into lakes
We've got fruit shipped from the Americas
We've got oil shipped from war zones
We've got clothes sewn by Asian children
Clothes sewn by little girls and boys
We've got a whole civilization built on the back of slaves
 and stolen ideas
Nothing is ever enough

Look at us [13]
Look at us all
Here at the opera while the world outside burns
While the world outside falls to pieces

We are Kings of France oblivious to the hiss of the guillotine
We are Romans lying in our own vomit as a mob gathers
 outside the gates
We are Troy
We are Pompeii
We are Venice sinking slowly beneath the waves
And there's a storm coming
A wolf coming from the south
A wolf crossing now the Mediterranean
On a makeshift raft
In a homemade life jacket
Coming now across a sea of bodies
The bodies of all the children we have allowed to drown
All the men and women
A wolf riding a tsunami
Riding a sandstorm
Riding a white-hot forever-summer we will not survive
There is a wolf coming from the south .
To deliver us from ourselves
We deserve nothing less
And she cannot be negotiated with
And she cannot be bought off
It's all blood money
Conflict diamonds
Spoils of war
Show me a banknote that is untainted
Show me what you've got
And how much by the way did you pay for this tonight?
How much is this costing you?
Whatever it is
Watch it now evaporate
Into these words
And this gesture
Watch us burn through your money

In the most obnoxious way we can

CADENZA [14]

We're going to let this pose mature a little [15]

Like a fine wine

In any other context
This pose would be obviously worthless
But as with anything put in a gallery
Whatever you put onstage takes on an intrinsic value
As a result of the money that's been paid to see it

This pose has a specific value
That grows second by second
The longer it's held for
Because the more of this show it occupies
The more box office takings it consumes
And for every second it sustains
It is worth a little bit more

And now more

And now more

With every passing moment
This pose consumes more of the time you have paid for

And then as well as the artistic value
There's also of course the human labour
How're you doing there iara?
How does that feel?
Have you got much more in you?

Grin and bear it

INTERLUDE

[16] *I can't remember what this bit was about.*
Perhaps I imagined it.

CANZONETTA

[17] Meanwhile
Back at the opera
Back in Seville
Susana is leading Figaro on a merry dance
While he watches from a bush
There will be a gentle comedy of errors
Everybody riding the carousel of desire and betrayal
All weightless
All air
Although just because the surface is thin
A little melodramatic
Too domestic
Too boring even
That doesn't make the feelings any less real
You can't make a feeling any less a feeling
You can't make what's real any less real
You can try to crush it down
Or reduce it
But it doesn't get any less real
Mothers hold their babies
Lovers hold each other
And the words coming out of their mouths might be nonsense
The emptiest of platitudes
The laziest of clichés
But none of it gets any less real
And you can try getting all cynical about it
The quiet rhythm of ordinary things
The slow daytime-television crawl of all the world
Running continuous and banal, yes, banal beyond belief
Of course it is
Nobody's saying that they aren't bored to tears of it all

Nobody's saying that the joke hasn't worn horribly thin
Thin enough to see right through to what's on the other side of it
Behind the glamour and the irony and the dry wit
A big sad face
And a field of boredom
Enough boredom growing out there for all of us
Enough boredom to feed the world
And yet still
You can't make any of it any less real
This is my hand
My heart beats ba-boom, ba-boom
And we can tell ourselves that there's a story happening
But there never is
It's just real things happening to other real things
Without any particular sense or meaning
While the music flows always underneath
You just have to stop listening to the words long enough
 to hear it
The blood singing in your ears
The birds singing about sex and desire
The wind singing about nothing at all
Our hearts singing their feelings to us

MELODRAMA

A little sentimental, perhaps
But then the opera is a good place for sentimentality
And for melodrama
We are lost deep in the plot now
And the lovers are lost in the garden
And in the dark
Their happiness will depend on whether or not
They can recognize each other's voices
Of course they will
As we will always recognize the voices of our own loved ones
The voices that compose us
Your choir of memories
And like the conductor you can wave your arms about
And try to make them all sing in time
Because without them you would be alone with the voice
 inside your head
Your own voice
That has been accompanying you, and us, all along
Never still or quiet
A voice that is yours and yours alone
That nobody else will ever hear
Nothing more than a quirk of evolution really
A flower in a desert

And now Susana
Immortal lover
Bride of Figaro
Lifts her bridal veil
And the soprano
Who is in some sense inside of or beneath her
Takes a deep breath
And as Mozart's hand guides her lips

Her tongue
So past
And present
And fiction
All fold in on each other

And to Mozart
Watching from the 18th century
Our lives must seem impossibly luxurious
And almost magical
A kind of paradise, in truth
A glittering landscape of electric lights and glowing screens
We just have to learn to live in it
And with each other
And with ourselves

As we rush together into a future that may already be in flames
Drawing behind us a comet-trail of glittering objects
Of devices and appliances
Incandescently useless
And if we shit gold tomorrow that's also for sale

How does it feel
To be so terminally at ease
No longer paying attention to the inflight safety demonstration
Barely conscious of your own breathing
While the world outside the theatre is in freefall
The sky is heating
And the waters are rising
And even if this is melodramatic
It is also absolutely true
And we can keep covering our eyes and ears
Until the screaming starts
And singing
Is not actually that far from screaming
It's just a matter of intention
And of degree
So scream if you want to go faster

And it will
There are no lifejackets under your seats, by the way
And the cushions won't be buoyant
But you might at least be able to hold on to each other
And we already have these blankets
To protect us from the cold
Good luck everybody

CONCERTATO 19

FINALE

Tonight, somewhere, somebody is singing
A ghost-choir of voices stretched all across the earth
And we can all sing along
Lose our voices in their voices
Lose ourselves
If the machines do eventually come to replace us all
What exactly will be lost
Our superstitions perhaps
Our myths
Our logical failings
Our failings in general
Our endless fragility
Our endless weakness
The movement of crowds
Traffic flow like a bloodstream
Holidays
Lazy Sundays in the park
Babies eating handfuls of sand on the beach
And lost in the face of a perfect and remorseless logic
The sense of uncertainty
The sense of wonder
The sense of doubt
Desire
Dancing
Sleep
Dreams
Don't be sad
We could have been better
But we could also have been worse
That much at least we're allowed to know

At the end of the opera
Figaro gets the girl
And happiness, we will have to presume
Of course he does
For the rest of us things are somewhat more complicated
The world outside the theatre is neither tidy nor kind
It asks for a generosity that will not be easy and will
 not be without pain
A generosity that will demand more than we think we can give
A generosity that will cost us
Grin and bear it
Why don't you
The music will always be playing
You just won't always be able to hear it
And you won't always like it
But anyway dance
Dance you fuckers
The fuck else have you got planned
For the rest of your life
Your real and actual life
Rushing back towards you now at astonishing speed
Almost here and you won't even have to applaud it's arrival
That's also been taken care of
So please brace yourselves
Because this has to stop somewhere

And so we stop here [20]

CURTAIN CALL [21]

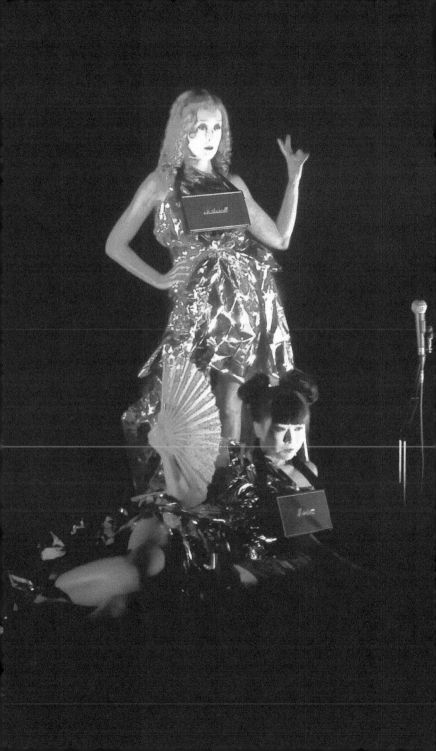

GLOSSARY

Overture – the instrumental introduction to an opera.

Prelude – a short introductory piece at the beginning of an opera or individual scene.

Duet – a piece for two instruments or voices.

Claque – a group of audience members paid by the theatre to laugh, applaud, etc, at appropriate moments; a common convention at the opera until the middle of the 20th century.

Cavatina – the first, slower part of a two-part aria.

Cabaletta – the second, faster part of a two-part aria.

Cadenza – the elaborate and ornate climax to an aria.

Recitative – a vocal composition that imitates the rhythm and pattern of ordinary speech.

Interlude – a short instrumental composition between two scenes.

Canzonetta – a type of secular vocal composition, generally dealing with pastoral, irreverent or erotic themes.

Melodrama – a dramatic work whose sentimental aspects are exaggerated with the intention of provoking emotions in the audience.

Concertato – a piece for multiple instruments and/or voices sharing the same melody.

Finale – the prolonged final scene of an opera.

APPENDIX I
SOME DESCRIPTIONS
OF SOME PICTURES

KIM KARDASHIAN

[1] Here is a stage, empty but for a small trampoline, stage left.

[2] Here is everybody, suddenly.

[3] Here is Tarleison, shadow-boxing.

[4] Here is Amanda, on the trampoline, in a shower of banknotes (BRL).

[5] Here is Renata, dragging Amanda – corpselike, bodylike – across the stage.

[6] Here is Elton, sharpening a knife.

[7] Here is Átila, holding a cloud of pink balloons shaped like baby sharks.

[8] Here is Crislla, watching the text appearing and disappearing on the back wall of the stage.

[9] Here is a group of grinning backing dancers in a big circular spotlight.

[10] Here is Elton, blowing up a rubber ring.

[11] Here is Amanda and Átila and Carine and Crislla and Elton and Renata and Tarleison, all spread across the stage, moving slowly in blue-green light like they're underwater.

[12] Here is Átila, tying her shoelaces.

[13] Here is everybody, dancing in sync while holding household appliances.

[14] Here is Renata, wearing a rubber ring like a tutu.

[15] Here is Carine with a leaf-blower, blowing the banknotes off the stage.

[16] Here is a scene we call "The Big Dance Scene".

[17] Here is Átila, wearing Minnie Mouse ears.

[18] Here is Carine, pushing a shopping cart across the stage; inside the shopping cart there is a television; on the screen we see You Know Who.

[19] Here is Crislla on the trampoline, suspended in pink and orange light, fading out.

KHLOÉ KARDASHIAN

[1] Here is a stage, empty but for a prop table covered in props, stage left, and a projection screen upstage, on which the opening lines of Chekhov's *Three Sisters* are now appearing; the desired effect of these two elements, in combination, is the sensation that what should be offstage is onstage, while what should be onstage is (somewhere) offstage.

[2] Here is Frank, dressed as a bear.

[3] Here is Lily, in a pink prom dress.

[4] Here is Kate, dressed as a pregnant pit girl, wheeling a television onto the stage; on the screen we see You Know Who.

[5] Here is Lily again.

[6] Here is Frank again.

[7] Here is Lily, applauding.

[8] Here is Sam, dressed to the nines.

[9] Here is Frank again.

[10] Here is Kate, now undressing, now removing her fake pregnancy belly, now slowly and meticulously putting bread into a toaster, now waiting for it to pop up while the stage fills with smoke.

[11] Here is Paul, dressed as a mechanic.

[12] Here is Tristan, dressed as a pope.

[13] Here is Lily again.

[14] Here is Paul, shooting Frank – still dressed as a bear – with a nerf gun.

[15] Here is Tristan again, still dressed as a pope.

[16] Here is Kate, speaking under coloured lights.

[17] Here is Tristan, sprinkling fake snow from the lighting rig.

[18] Here is Paul, reading the final lines of *Three Sisters* as they appear on the projection screen, karaoke-style.

KOURTNEY KARDASHIAN

[1] Here is a stage, empty but for a table holding the lighting and sound desks plus various other electronics, stage left.

[2] Here is Sammy, dressed as the conductor.

[3] Here is iara, in light so dim she's a golden blur.

[4] Here is sometimes Nhung, or sometimes Rebeca, emerging slowly out of the darkness, wearing an amplifier around her neck, from which a voice is singing.

[5] Here is iara, holding a tape measure and wearing an amplifier around her neck, from which a voice is singing.

[6] Here is iara, and here is sometimes Rebeca, or sometimes Nhung; the light scatters off the gold emergency blankets that they wear like ball gowns.

[7] Here is iara under a spotlight, in a shower of banknotes (USD).

[8] Here is a ghost.

[9] Here is the sound of laughter and cheering and applause, playing out of two amplifiers at the back of the audience; the amplifiers are wearing bowties.

[10] Here is a dance.

[11] Here is iara, looking at you through opera glasses.

[12] Here comes sometimes Rebeca, or sometimes Nhung, carrying a small treasure chest; inside the treasure chest there are two sheets of 24 carat gold leaf.

[13] Here is an image like something from a perfume advert, in pink light and thick haze.

[14] Here they are eating the gold.

[15] Here is iara, holding a pose for a really, really long time.

[16] Here is a small robotic horse walking jerkily across the stage.

[17] Here is sometimes Nhung, or sometimes Rebeca, alone onstage as the voice singing from her amplifier collapses into a hum of feedback.

[18] Here is a kind of inflight safety routine that becomes increasingly abstract and violent.

[19] Here is the sound of birdsong and a baby crying.

[20] Here is a sudden blackout, and silence.

[21] Here is canned applause.

APPENDIX II
TOWARDS A KIND OF DRAMATIC STASIS (2018)

Over the last decade or so we've found ourselves circling a more or less unspoken set of rules and objectives (or more like desires), that are ridiculously absolute and bloody-minded and sort of dumb and not entirely serious but they've steered us, remorselessly, from wherever we came from (we can barely remember) to wherever we're going (no idea). In truth what we're circling is a kind of ideal show, a beacon pulsing somewhere in the distance, towards which we move sometimes closer, sometimes further. The question of whether or not this ideal show (if we were ever to make it) would actually be any good is essentially irrelevant; what matters is the dance towards and away from it, the promise and the betrayal – or last-minute refusal – of that promise. (Artistic practice perhaps anyway being defined by the exact point at which you retreat from whatever it is that you're approaching).

The following – which in truth is just one version of many contradictory versions – was written in early 2018, shortly after we finished Khloé *and just as we were starting to work on* Kourtney.

1 The show consists of *a single sustained moment* without beginning or end.

2 Every section of the show – insofar as the show has different sections – could be the beginning, or the middle, or the end – insofar as the show has a beginning, or a middle, or an end.

2.1 Transitions between different sections of the show should be all but invisible.

2.2 The sequencing of sections is intuitive, musical, which is to say more or less arbitrary and subjective; things could be any other way, almost.

3 There is no argument (as such) or narrative (at all).

3.1 In place of narrative there is suspension, stasis, which is to say everything and nothing at the same time.

3.2 In place of narrative there is an arrow always in flight, always in movement, endlessly halving the distance left to the target but never reaching it.

3.3 Something is always happening but nothing ever *happens*.

4 The only thing that we ever really ask of art is that it make the world *present* in a way that our everyday lives refuse, negate; that it make the world fully *there*, completely and tangibly and truly. It need do nothing else.

4.1 To do this (for us) demands the kind of unwavering, timeless suspension impossible in real life.

4.2 To do this risks boredom, or worse.

5 There is no set up, no pay off, no filler; every section is complete in and of itself; every section is enough.

5.1 Every bit of the show is the best bit of the show, because the different bits of the show are fundamentally identical.

6 The stage presents a single image that fluctuates almost imperceptibly.

6.1 Shifts in light simulate movement and change that are otherwise absent.

6.2 Structure and momentum are evoked by music and sound.

6.3 Any actual movement is glacial – just another shade of stillness, really.

7 The show is like a massive object moving constantly towards the audience but never actually arriving.

7.1 The show is like all the world approaching us, arms out, beckoning.

Sleepwalk Collective is an award-winning live-art and experimental-theatre group creating fragile, nocturnal performances between the UK and Spain. Formed in London in 2006 by iara Solano Arana (Spain), Malla Sofia Long (Finland) and Sammy Metcalfe (UK), they currently live and work between Madrid and Vitoria-Gasteiz. Shows include *As The Flames Rose We Danced To The Sirens, The Sirens* (2010), *Amusements* (2012), *Karaoke* (2013), *Domestica* (2014), *Actress* (2015), *Kim Kardashian* (2016), *Khloé Kardashian* (2017), *Kourtney Kardashian* (2018), and *Swimming Pools* (2020).

Kim Kardashian *was created in collaboration with the Balé da Cidade de Palmas (Tocantins, Brazil), and supported by the Fundação Cultural de Palmas.*

Khloé Kardashian *was created at and supported by Arden School of Theatre (UCEN Manchester), in collaboration with the Theatre and Performance course.*

Kourtney Kardashian *was commissioned by the Festival de Clásicos en Alcalá, and was created at and supported by Sala Baratza Aretoa and Battersea Arts Centre.*

Printed in the USA
CPSIA information can be obtained
at www.ICGtesting.com
JSHW072029140824
68134JS00045B/3850

9 781913 630089